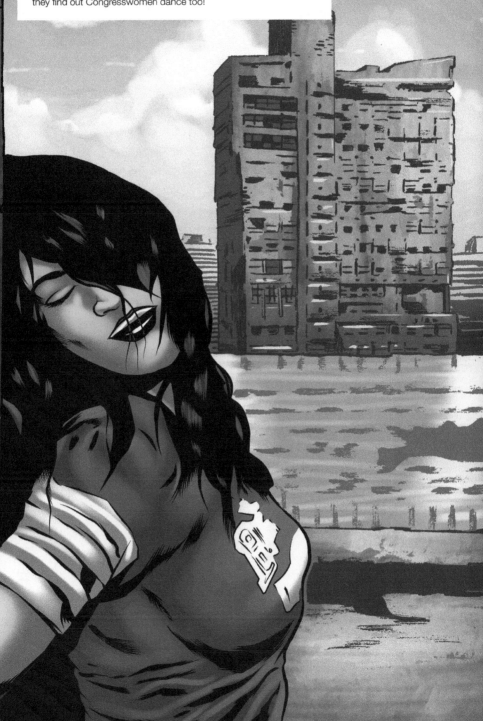

"WELL-BEHAVED WOMEN SELDOM MAKE HISTORY." -LAUREL THATCHER ULRICH, 1976

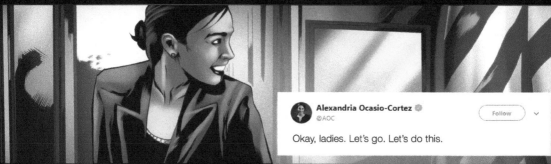

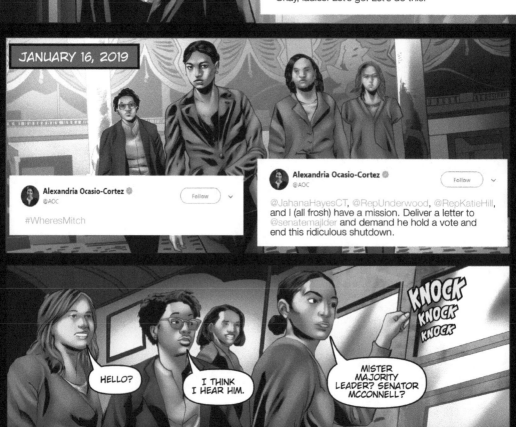

MISTER McCONNELL?

ARE THEY GONE?

I THINK I HEAR THEIR HEELS CLICKING ON THE FLOOR. YEAH...

Alexandria Ocasio-Cortez ✓
@AOC
Follow

#WheresMitch has taken the government hostage. We need 60 votes to end it. But it has to go to the floor first!

Leader McConnell ✓
@SenateMajLdr
⚙ Follow

With bipartisan cooperation, the Senate can send a bill to the House quickly so that we can take action as well.

Leader McConnell ✓
@SenateMajLdr
⚙ Follow

The situation for furloughed employees isn't getting any brighter and the crisis at the border isn't improved by show votes.

THEY'RE DEFINITELY MOVING AWAY.

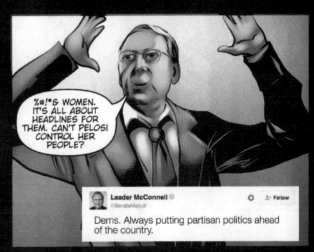

%#!*& WOMEN. IT'S ALL ABOUT HEADLINES FOR THEM. CAN'T PELOSI CONTROL HER PEOPLE?

Leader McConnell ✓
@SenateMajLdr
⚙ Follow

But the President's plan is a path toward addressing both issues quickly.

Leader McConnell ✓
@SenateMajLdr
⚙ Follow

Dems. Always putting partisan politics ahead of the country.

Donald J. Trump ✓
@realDonaldTrump

So interesting to see "Progressive" Democrat Congresswomen, who originally came from countries whose governments are a complete and total catastrophe, the worst, most corrupt and inept anywhere in the world (if they even have a functioning government at all), now loudly......
8:27 AM - 14 Jul 2019

Donald J. Trump ✓
@realDonaldTrump

....and viciously telling the people of the United States, the greatest and most powerful Nation on earth, how our government is to be run. Why don't they go back and help fix the totally broken and crime infested places from which they came. Then come back and show us how....
8:27 AM - 14 Jul 2019

Donald J. Trump ✓
@realDonaldTrump

....it is done. These places need your help badly, you can't leave fast enough. I'm sure that Nancy Pelosi would be very happy to quickly work out free travel arrangements!
8:27 AM - 14 Jul 2019

🔴MSNBC

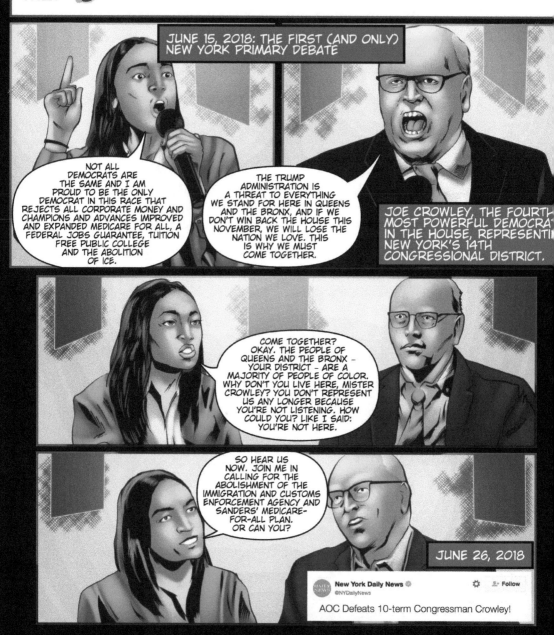

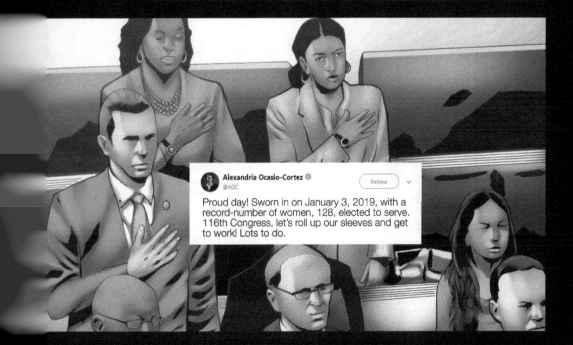

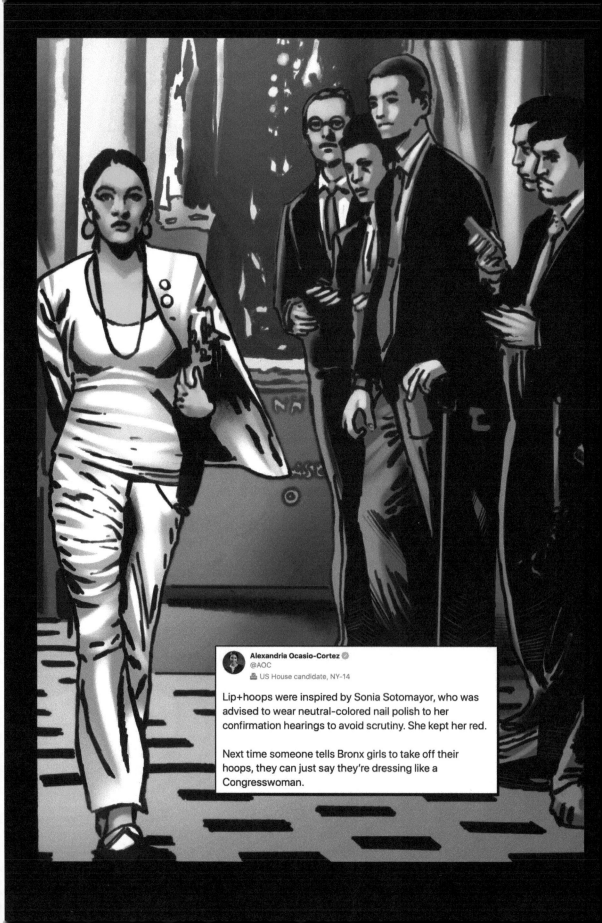

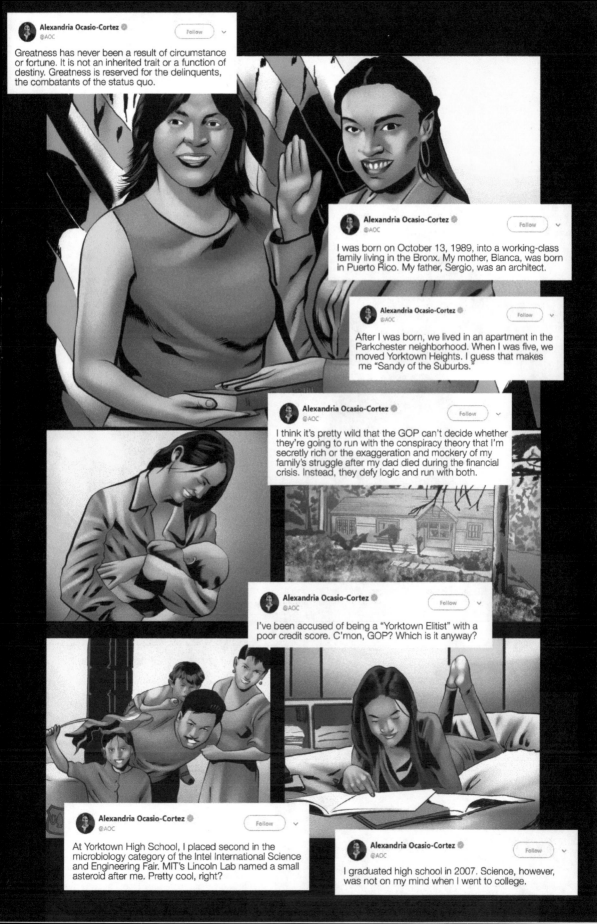

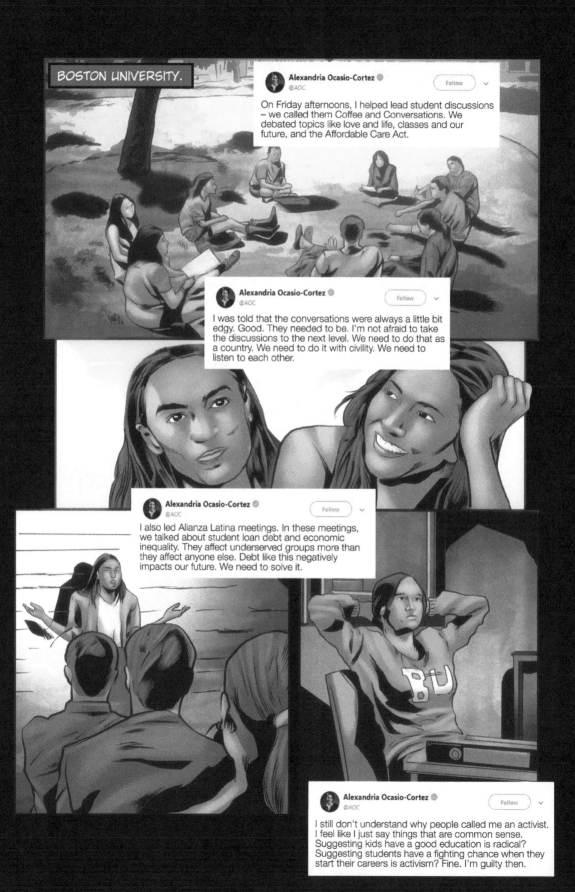

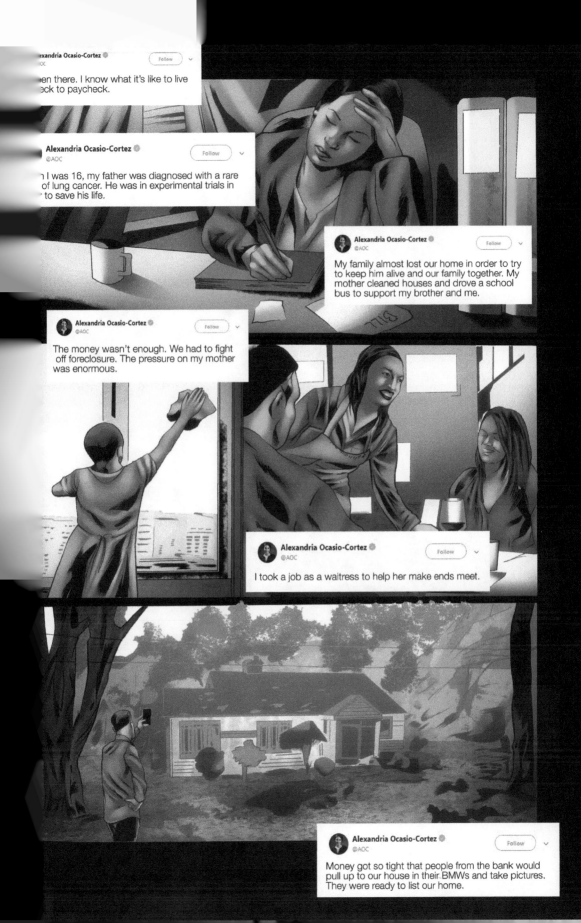

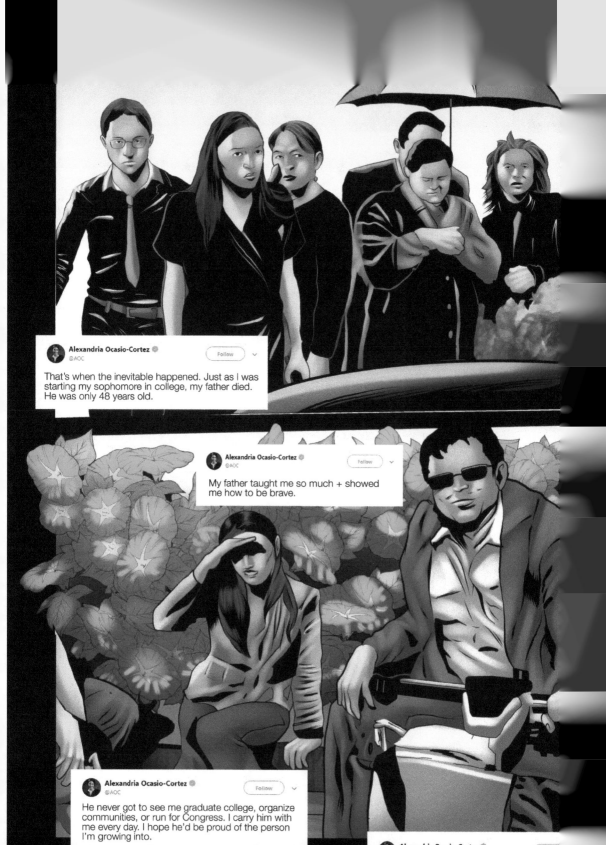

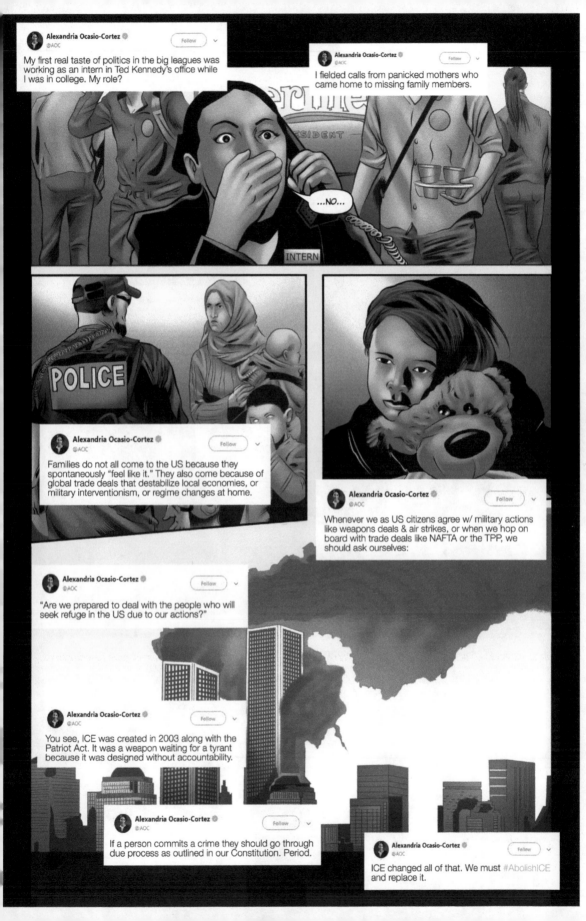

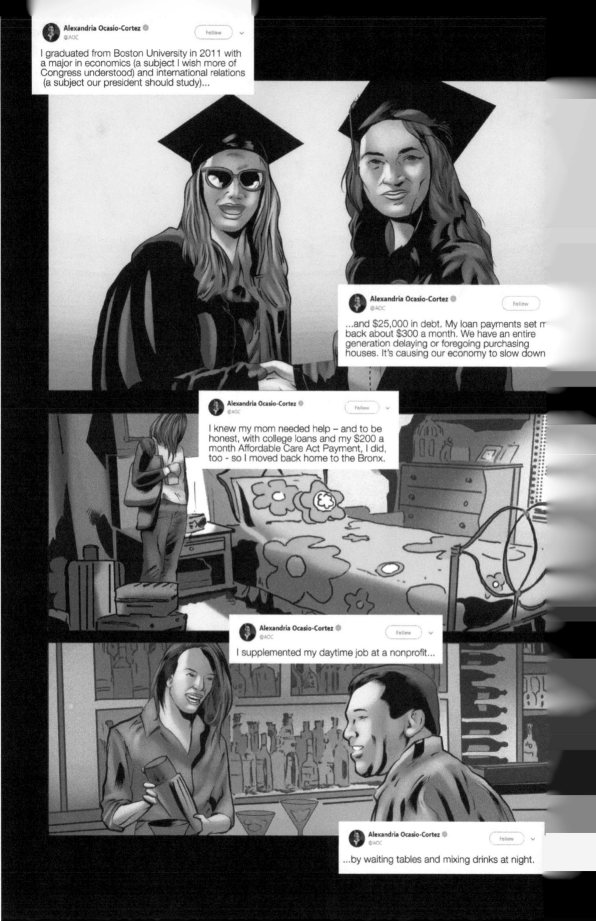

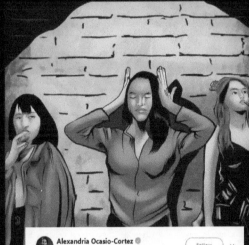

THANK YOU.

OF COURSE. ALWAYS! LET ME CALL YOU AN UBER.

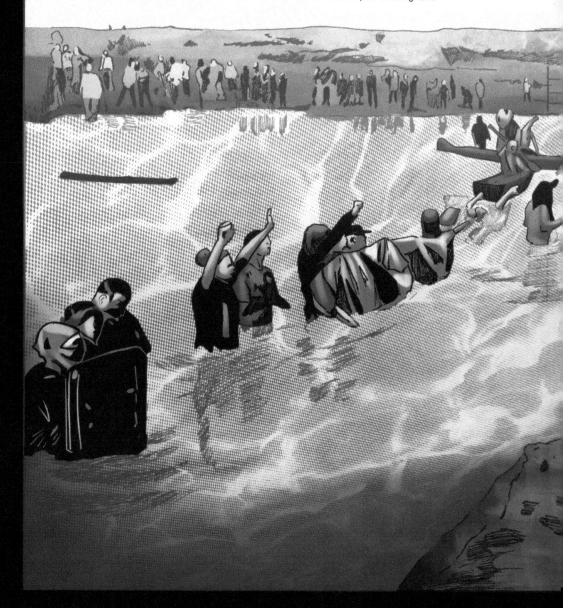

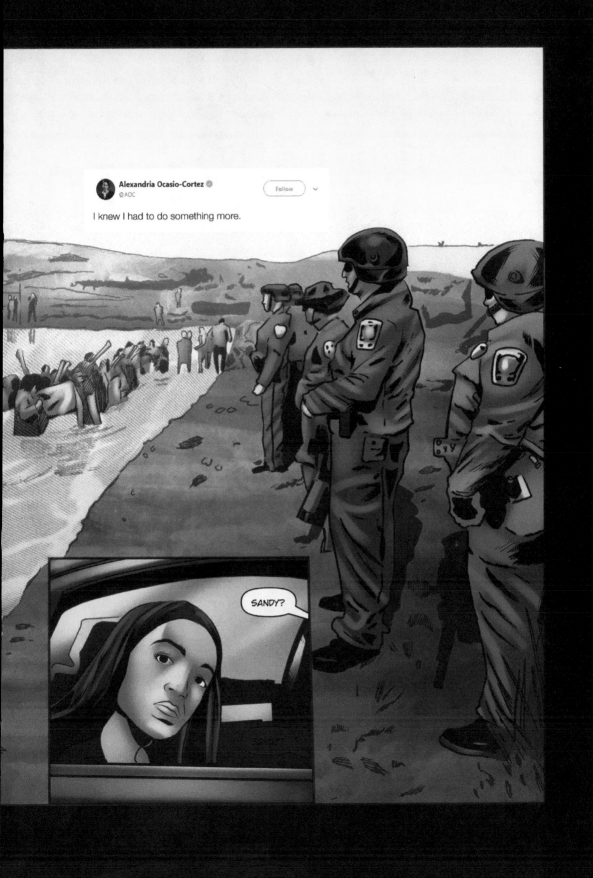

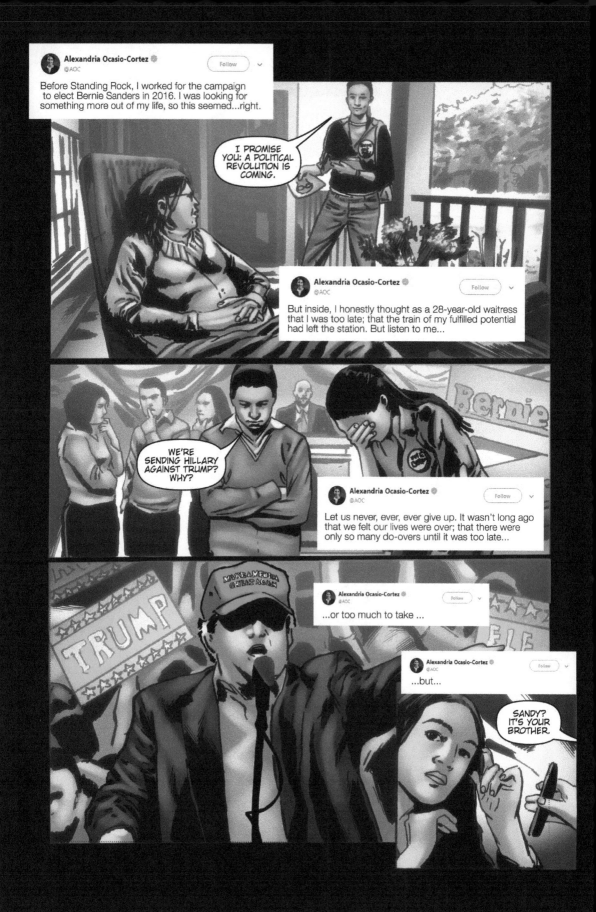

GABRIEL YOU... YOU SUBMITTED MY NAME TO... WHAT? THE BRAND NEW CONGRESS?

ARE YOU CRAZY? THEY'LL NEVER CALL ME. I'M...

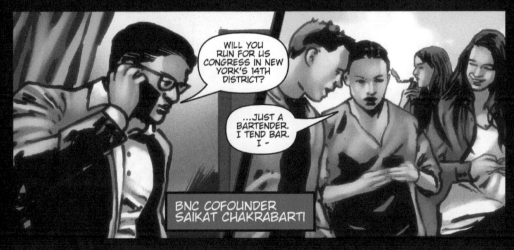

WILL YOU RUN FOR US CONGRESS IN NEW YORK'S 14TH DISTRICT?

...JUST A BARTENDER. I TEND BAR. I –

BNC COFOUNDER SAIKAT CHAKRABARTI

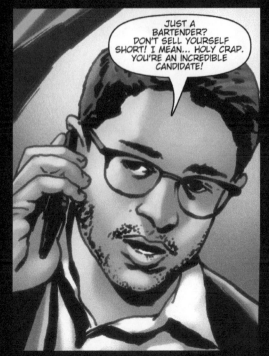

JUST A BARTENDER? DON'T SELL YOURSELF SHORT! I MEAN... HOLY CRAP. YOU'RE AN INCREDIBLE CANDIDATE!

WELL, SANDY? WHAT'CHA GONNA DO?

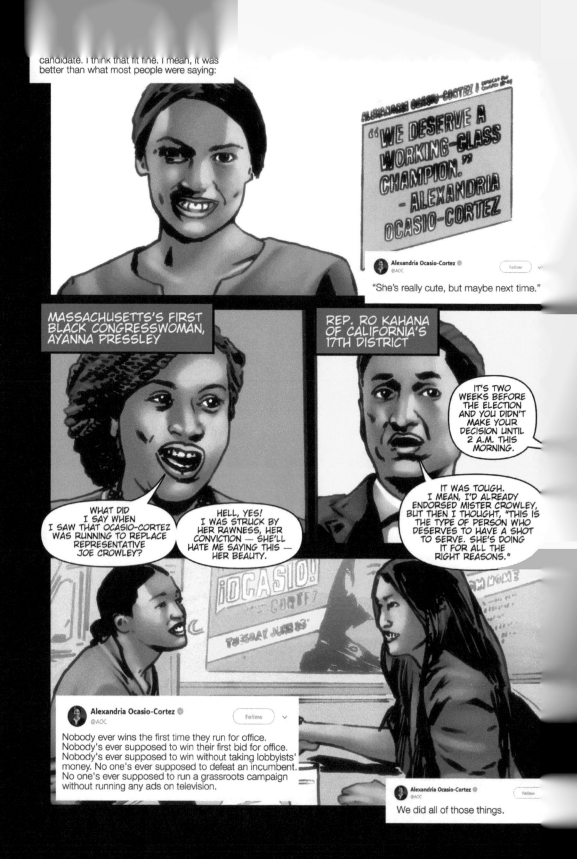

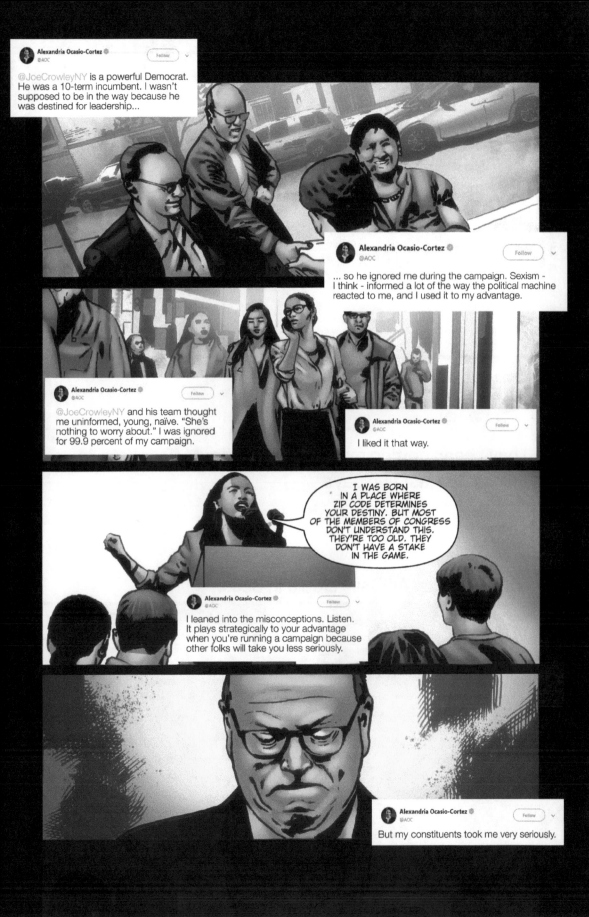

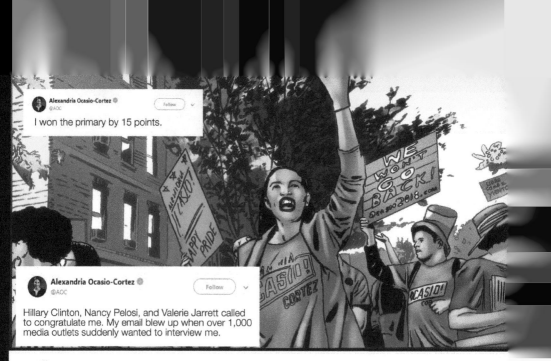

Alexandria Ocasio-Cortez @AOC
Follow

I won the primary by 15 points.

Alexandria Ocasio-Cortez @AOC
Follow

Hillary Clinton, Nancy Pelosi, and Valerie Jarrett called to congratulate me. My email blew up when over 1,000 media outlets suddenly wanted to interview me.

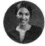

Alexandria Ocasio-Cortez @AOC

US House candidate, NY-14

I have been getting many inquiries about my debate lip color in the last two days.

I GOT YOU.

It's Stila "Stay All Day" Liquid in Beso.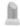

Alexandria Ocasio-Cortez @AOC
Follow

A simple Tweet about my lipstick color caused it to sell out in a day.

Alexandria Ocasio-Cortez @AOC
Follow

In May 2017, I had 300 Twitter followers. By primary day, that grew to 60,000, and it continues to grow every single day.

Alexandria Ocasio-Cortez @AOC — Follow

Women like me aren't supposed to run for office. It's not just that I'm a woman of color running for office. It's the way that I ran. It's the way that my identity formed my methods.

Alexandria Ocasio-Cortez @AOC — Follow

Millennials and people, you know, Gen Z and all these folks that will come after us are looking up and we're like: The world is going to end in 12 years if we don't address climate change and your biggest issue is how are we gonna pay for it? This is the war — this is our World War II.

Alexandria Ocasio-Cortez @AOC — Follow

My entire adolescence was shaped by war, was shaped by the increased erosion of our civil liberties and privacy rights, and then was shaped as soon as I got into college by a ground-shaking recession that has haunted our economic outcomes ever since.

Alexandria Ocasio-Cortez @AOC — Follow

My generation has never seen an America where the fruits of capitalism have actually been good for an entire generation of millennials. So they mock me:

RADIO PERSONALITY SEAN HANNITY

THE GREEN NEW DEAL? C'MON! AND DID YOU SEE THE OCASIO-CORTEZ DANCING VIDEO? TAKE A LOOK IF YOU HAVEN'T. YOU'LL SEE AMERICA'S FAVORITE COMMIE KNOW-IT-ALL ACTING LIKE THE CLUELESS NITWIT SHE IS.

RADIO PERSONALITY RUSH LIMBAUGH

IS THE OCASIO-CORTEZ'S GREEN NEW DEAL AN EARLY OVERREACH BY A WACKY FRESHMAN DEM? HERE'S THE DEAL, FOLKS. SHE BELIEVES THAT IF WE DON'T ADDRESS CLIMATE CHANGE - CAUSED BY COW FARTS DESTROYING THE OZONE OR SOMETHING - THE WORLD WILL END IN TWELVE YEARS.

OH! AND SHE CLAIMS THAT THE TWELVE YEARS STATEMENT WAS JUST DRY HUMOR AND PEOPLE DON'T GET IT. SHE DIDN'T REALLY MEAN IT. WELL, SHE DID. SHE MEANT IT TO BE TAKEN SERIOUSLY.

SHE MEANT IT TO BE RECEIVED EXACTLY AS IT WAS. AND THEN SHE HAD THE GALL TO TELL US IN A TWEET THAT CONSERVATIVES DON'T GET DRY HUMOR?

DON'T TELL ME ABOUT PEOPLE THAT DON'T GET HUMOR. DON'T TALK TO ME ABOUT PEOPLE THAT DON'T UNDERSTAND DRY HUMOR AND SARCASM. WE GET IT, AOC. WHEN THINGS ARE FUNNY, WE GET IT. BUT YOU WOULDN'T KNOW FUNNY IF IT BIT YOU ON YOUR PRETTY LITTLE NOSE.

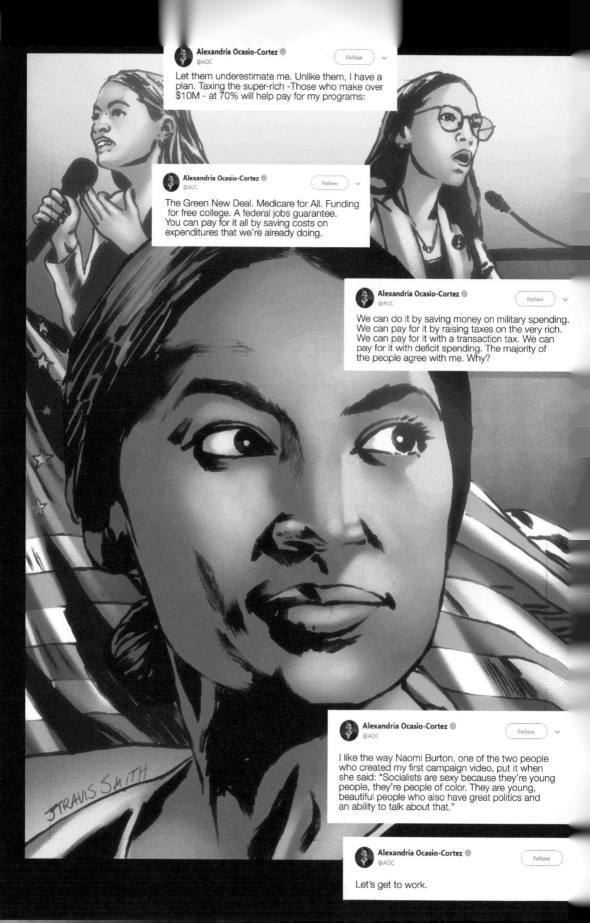

TIDALWAVE
COMICS

Michael Frizell ———————————————— Writer

J. Travis Smith ———————————————— Pencils

Jesse Hansen (pages 1-15)
J. Travis Smith (pages 16-22) ——————— Inks

Iwan Joko Triyono ——————————————— Colors

Dave Ryan ————————————————————— Cover

Darren G. Davis
Publisher

Maggie Jessup
Publicity

Susan Ferris
Entertainment Manager

Benjamin Glibert - Letters

★FEMALE★FORCE★

KAMALA HARRIS

CPSIA information can be obtained
at www.ICGtesting.com
Printed in the USA
BVHW021141200121
598225BV00019B/113

9 781949 738285